Tattooing and Body Piercing

Understanding the Risks

Kathleen Winkler

Enslow Publishers, Inc.

40 Industrial Road PO Box 38
Box 398 Aldershot
Berkeley Heights, NJ 07922 Hants GU12 6BP
USA UK

http://www.enslow.com

Library of Congress Cataloging-in-Publication Data

Winkler, Kathleen.
 Tattooing and body piercing : understanding the risks / Kathleen Winkler.
 p. cm. — (Teen issues)
 Includes bibliographical references and index.
 ISBN 0-7660-1668-4
 1. Tattooing—Juvenile literature. 2. Body piercing—Juvenile
 literature. I. Title. II. Series.
 GN419.3 .W56 2002
 391.6'5—dc211

 2001002338

Printed in the United States of America

10 9 8 7 6 5 4 3 2 1

To Our Readers:
We have done our best to make sure all Internet addresses in this book were active and
appropriate when we went to press. However, the author and the publisher have no
control over and assume no liability for the material available on those Internet sites or
on other Web sites they may link to. Any comments or suggestions can be sent by e-mail
to comments@enslow.com or to the address on the back cover.

Illustration Credits: © Corel Corporation, p. 32; Drawing by John Webber,
engraving by William Sharp, pp. 13, 14; Enslow Publishers, Inc., pp. 20, 44, 51;
Ralph Winkler, pp. 7, 9, 19, 25, 27, 30, 46.

Cover Illustration: Skjold Photos.

Contents

1

What Are Tattoos and Body Piercings?

"I've got four of them. Hopefully, I'm going to get more. They are kind of addicting, at least for me."[1]

Marsha, age thirty-two, is talking about her tattoo "collection," something she started when she was eighteen. She has a small black band braceleting her wrist, a black rose blooming on her chest, and her shoulder sports a Chinese yin/yang symbol. The last one, on her ankle, she says is different. "I designed it myself. It's a sword with a snake wrapped around it going through a skull, about four inches long," she says. "I wanted something that nobody else had."[2]

Her reason for the tattoos? "I love art," she says. "It's an expression of art, a walking artboard."[3] Marsha does not think she will ever regret her tattoos. "This is part of my life, it's like a diary," she says. "It's part of who I am, and I have no regrets. If I have children I hope they'll look at them and go, 'Mom, that's very cool.'"[4]

Lisa, age thirty-three, feels a little differently. Her boyfriend, who was a professional tattoo artist, did her tattoos. First came a rose on her shoulder, then a spiderweb on her back, a butterfly on her hand, and a flower on her leg. The flower is not finished. It was outlined but never filled in. "I was drinking when I got some of them. I really don't want them anymore," she says firmly. "They don't look good. They don't look nice when you go formal. I can't wear anything strapless because the one on my back looks tacky. I just think they look trashy."[5]

William, age twenty-six, had his tongue pierced five years ago. "A bunch of my friends were getting theirs done and it was like a fun thing to do," he says. "It didn't really hurt at the time, most of the pain came trying to eat afterwards. We went to Burger King and I couldn't eat the hamburger at all, just a few fries. At home I ate soup and oatmeal for a few days. But it was fun, and I'm pretty happy with it now. I have bleached hair, some tattoos, and I act kind of different. I'm a nonconformist. This is what I want."[6]

William's wife, Vicki, thirty-three, got her navel pierced while William was being tattooed. They were on vacation in Florida at the time and she admits she did it on an impulse. "It hurt so much, he heard me in the tattoo area downstairs!" she remembers. "I walked out of there with my shorts unbuttoned; I didn't want anything to touch it, even the wind to blow on it."[7] She had no trouble with healing, however, and is now happy with her piercing and plans to keep it forever.

Beth, eighteen, did not have the same good results. Her navel piercing has become infected repeatedly. "I keep it really clean, and I was really careful when it was first done," she says, "but it gets infected off and on. Everybody tells me to take it out, but I'm going to try to keep it because I like it. If it gets really bad, then I'll take it out."[8]

Different people had different results. But they went

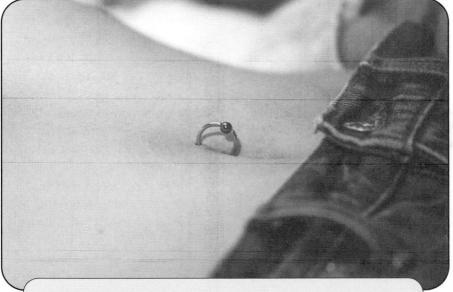

People get body piercings for various reasons, with different results.

through basically the same process in getting their tattoos and piercings.

What Is a Tattoo?

Tattoos are done by injecting ink under the first layer of skin skin, into the second layer, called the dermis. A tattoo machine is a tube that holds a bar with needles attached to the tip. It is controlled by a foot pedal, similar to the way a sewing machine is run. It may have one needle for doing outlining or many needles for filling in color. The needles go about 1/8 inch deep, about thirty times a second or faster.

Many people worry about how the needles will feel. Will it hurt like getting an injection? The answer depends on the individual person's pain threshold, the location of the tattoo

(some places, such as the underside of the arm, are more sensitive), the skill of the artist, and the condition of the needles.[9] Some people find it very painful, some say it just stings a little, and some say it does not hurt at all.[10] Some good comparisons might be the sting of frying bacon fat hitting the skin, or the pain of a sunburn.

There are a lot of different tattoo styles. Many of the designs are drawn in advance; they are called "flash." Customers pick out the design they want from a book or from flash on a wall. Other tattoos are designed for the individual person. Some of the most common styles are:

- ⚬ Tribal—All black with thick lines, they look like designs by Native Americans or the famous tattoos of the Maoris in New Zealand.
- ⚬ Traditional—Hearts and banners, roses, or military symbols made famous by sailors, especially in the past.
- ⚬ Black and gray—Often done with delicate shading, can be very artistic.

The Structure of the Skin

The skin is made up of two layers. The top one, the epidermis, ranges from one-fiftieth to one-quarter inch thick. Cells at the bottom divide to make new cells as old ones dry out and flake off. The average person's skin sheds nine pounds of cells a year.[11] It takes about a month for a cell to move up to the top of the epidermis.

Below the epidermis is a thicker layer called the dermis, rich with nerves, sweat glands, hair follicles, and blood vessels (why body piercings may bleed). Tattoos must go into the dermis to last.[12]

People who do not want to design their own can choose a tattoo from a book of designs or from a wall of flash. These designs are drawn in advance.

- Classical—Reproductions of classic art done by famous artists such as Van Gogh.
- Oriental—Flowers, dragons, and other animals from myths that look like they came from China or Japan.
- Devotion tattoos—May be religious or from cults, the names of relatives, friends, romance partners, or memorials to dead people or animals.
- New school—Graffiti-like symbols with heavy outlines and bright, vivid colors such as those found in spray painting.

⬯ Gothic—Sometimes called the dark side of tattooing, these are shocking images like skulls, dripping blood, daggers, and occult or gang symbols.

⬯ Membership—Gang symbols.[13]

What Is Body Piercing?

Body piercing means putting a sharp needle through a body part and then putting a piece of jewelry into the hole. Piercing guns are not safe since they cannot be sterilized between uses. A better method is doing the piercing by hand with a sterile needle. Piercing jewelry is made from surgical stainless steel, the same type doctors use for implants. The most popular places to pierce (besides earlobes) are upper ears, noses (both the nostril and the divider called the septum), eyebrows, cheeks, beneath the lower lip (called the labret), tongues, and navels.[14]

People thinking about getting either a tattoo or a body piercing need some information before making the decision. They also need to think long and hard because tattoos and body piercings are meant to last forever. Yes, they can some-times be removed. But they do not always disappear completely, and they can leave scars—sometimes serious, ugly scars. Tattoos and piercings can send a message about a person during a job or college acceptance interview, a message the person may not want to send. Parents may be upset when a teen gets a tattoo or piercing, and most teens depend on their parents for emotional and financial support. So, a tattoo or piercing should never be done without careful thought.

This book will consider all sides of the issue of tattoos and piercings and include complete information about making the decision.

2

Body Decoration in History

Decorating the body with tattoos or piercings is not something new. People have found ways to decorate their bodies since ancient times. Tattooing seems to have come first.

Ancient, Eastern, and Tribal Tattooing

People who study ancient cultures, called archaeologists, have found carved figures from Stone Age people showing some sort of tattooing. Figures found in Europe dating from 6000 B.C. and Egyptian figures and mummies from 4000 B.C. both show patterns and symbols that were probably a form of tattooing. Human bodies found frozen in ice in Siberia have tattoos of animals.[1]

Tattooing seems to have been done in all cultures by most indigenous people. It was especially common in India, China,

Japan, the Pacific Islands, Australia and New Zealand. South American explorers probably carried the idea to the Aztec, Inca, and Mayan people. The art reached its peak with the Maori tribes of New Zealand. Both sexes were tattooed, with the men showing importance by having most of their bodies covered with designs. Many tribal tattoos were religious or representative of magic.[2]

Many people think Japanese tattooing during the 1700s—pictures of gods, animals from myths, and heroes from folk stories—was the most artistic ever done. In the 1800s, the Japanese emperor outlawed tattooing. It did not die out however, but went underground. Western visitors, such as sailors and explorers, still came back with beautiful tattoos.[3]

Western Tattooing

Tattooing was done by the ancient people who lived in the British Isles. Roman soldiers who took over England adopted tattooing, but Emperor Constantine banned it in 300 A.D. It continued in England until the Church banned it there too, in the 800s A.D. Later, the Crusaders tattooed Christian symbols on their bodies in case they died in a non-Christian land.

Captain James Cook, the famous British explorer, made tattooing popular in England again during the 1700s. He saw many beautiful tattoos while he was exploring the South Pacific, especially on the island of Tahiti. Before Cook, tattooing was called "pricking." Cook brought back the Tahitian word *ta-tu*, which means "to strike" (because the islanders used mallets to strike a sharp piece of bone when doing a tattoo). This became the English word "tattoo." He also brought a beautifully tattooed man named Omai to England with him. Tattooing became a fad. Czar Nicholas II of Russia, King George of Greece and many members of the British royal family were tattooed.[4]

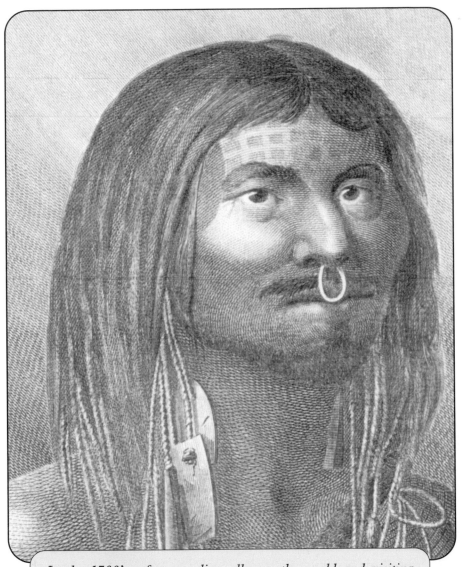

In the 1700's, after traveling all over the world and visiting countries such as the one where this man is from, where tattooing and body piercing were common, Captain Cook returned to England and made tattooing popular again.

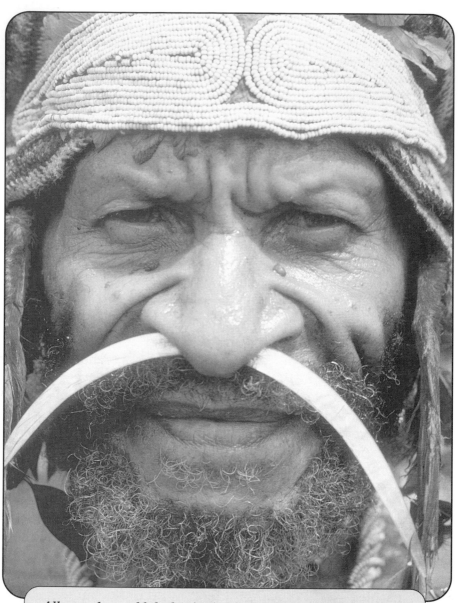

All over the world, body piercing is done for religious or cultural reasons.

Tattooing in the United States

The first professional tattooist in the United States was Martin Hildebrand, who tattooed soldiers and sailors during the Civil War. In the 1890s, a Japanese master tattooist came to New York and taught Asian methods and designs.[5]

Tattoos had always been done one needle at a time. It became easier when Samuel O'Reilly invented the electric tattoo machine, which he called the tattaugraph. With it, tattoos did not hurt as much, and the tattooist did not need as much training.

For a while tattooing was all the rage; heavily tattooed people were displayed in circus sideshows. But in the early 1900s that changed. People started to think of tattooing as low class, done only by the uneducated. It was not until the 1970s, 1980s, and 1990s that tattooing exploded in popularity.

History of Body Piercing

Compared to tattooing, not as much is known about body piercing in ancient times because piercing holes eventually grow shut after the piercing object is removed.

But we do know that many tribes in Africa performed religious piercings. Some believed that demons could fly up people's noses but nose rings would keep them out. Others thought evil spirits could get in through ears, so they pierced them. Piercing was sometimes used to show rank or social level; Roman slaves had special piercings.[6] Egyptians and Pharoah's pierced their nipples to show manhood. The Mayans of South America pierced their tongues as part of a religious ritual.[7] Some men in Borneo had their sexual organs pierced with bones.[8]

People have decorated their bodies in the past, but why do teens today choose body decoration? What risks are they running? We will look at these issues.

3

Who Is Doing This and Why?

I thought it would be interesting and all my friends said it was really fun, really cool, and it doesn't hurt. You're not hurting anybody.

Kim, age eighteen, tongue piercing[1]

My boyfriend got one, and then he came with me when I got mine. It was kind of just for fun. No one else I knew had one so I thought I could be a little different. Mine aren't offensive, so I don't think it would ever give me a problem in finding a job.

Heather, age twenty-two, three tattoos[2]

For many years tattoos were looked down on as something done by people like gang members or criminals. That started changing in the late 1970s when the baby boomers began to experiment with tattoos and body piercing. Tattoos and body piercings are now becoming part of the mainstream culture.

Tattooing, especially, is "moving away from historical roots as a disvalued craft while. . . being defined as an art form," says a college professor who has done serious research into the tattoo culture.[3]

Even the American Museum of Natural History in New York has had an exhibit on the art of tattooing. A spokesperson for the museum says, "There are a lot of people now who see tattooing as a work of art and see the skin as a kind of media that is quite unique."[4]

Just how common are tattooing and body piercing? Experts guess that between 7 and 20 million adults in the United States have tattoos.[5] Forty percent of those getting tattoos today are women.[6] When the Texas Tech University School of Nursing in Lubbock, Texas, did a study of 2,100 teenagers, they found that one in ten had a tattoo and over half were interested in getting one. The teens in the survey came from all income levels and most of them earned As and Bs in school.[7]

Body piercings are harder to count because many people pierce themselves, but Gauntlet, a chain of body piercing shops in California, New York, and Paris, says it performs thirty thousand piercings a year.[8] In a survey of 828 college students, 51 percent had a piercing other than the earlobe.[9]

There are many reasons for doing anything, and body decoration is no different. Laura Lees, a psychologist who works with teenagers, says that in her practice she sees teens getting tattoos or piercings as a way of developing a sense of identity. "During the 90s we had the grunge look with ripped clothes and messy hair, and that's where this look came in," she says. "A lot of it is just a fashion statement, you see it in fashion magazines and rock videos. And some of it can be experimental behavior—'I wonder what it would be like to have this kind of thing.' It can also be part of fitting in with the group: 'Other people have it, I want it.'"[10]

She also points out that getting a tattoo or piercing can be

Reasons Students Gave for Getting Body Art[11]

Tattoos:

- For self-expression . 53%
- Just wanted one . 35%
- To remember an event . 21%
- To feel unique . 17%
- To express independence 11%

Body Piercing:

- For self-expression . 48%
- Just wanted one . 38%
- To be different. 21%
- As a beauty mark . 21%

The numbers add up to more than 100% because respondents could choose several categories. Many of them had multiple reasons.

a form of what she calls passive rebellion for teens. "Their parents probably don't want it, so it's something they can fight for, something different from what their parents do," she says.[12]

The college professor who researched tattoos found a number of different reasons for why people got tattoos. Most of those he interviewed said it was because they knew other people who had a tattoo. Many said they did it on impulse; 58 percent said they had never been in a tattoo studio before getting their first one. Sixty-four percent said they got their first tattoo while with a family member or friend. Many young people in his survey got tattoos to mark a special time in their lives, especially "becoming an adult" or "moving out on my own." Sometimes a group of friends all got the same tattoo as

Tattooing, like body piercing, is done for various reasons. It might be done to celebrate a special event, as a mark of friendship, or just because the person likes the way it looks.

a mark of friendship. Some people said they wanted to look different or to rebel just a little.[13]

The nurse who did the Texas Tech University School of Nursing research said that the students she interviewed did it for their own self-identity. "They talk about feeling good, feeling unique," she said. "They said, 'It made me feel special.' It is an internal symbol of themselves."[14]

People in the college professor's survey chose their particular tattoo design for different reasons. Some wanted to show how much they cared about someone, so they had the person's name tattooed. Some wanted to show they were members of a group, so they got matching tattoos. Some got tattoos related to their hobbies, interests, or religious beliefs. Some chose a

Choosing a specific design for their tattoo can make a person feel unique.

design to show what they thought about themselves. And some chose a design just because it was beautiful.[15]

Some teenagers get tattoos because famous people they admire have them. The list of tattooed people in sports and entertainment gets longer every day. It includes Roseanne Arnold, Whoopi Goldberg, Melanie Griffith, Mark Wahlberg, Scottie Pippen, Michael Jordan, and Dennis Rodman among many others.[16]

Some states or city health departments regulate tattoo and body piercing; others states are in the process of passing laws. The laws vary from state to state, but every place that allows tattooing has some kind of age limit, usually eighteen. At this writing, tattooing is banned in Massachusetts, Vermont, Oklahoma, and South Carolina; it became legal in New York in 1996. Researchers estimate that there are about twelve thousand licensed tattoo artists around the country.[17]

Responsible tattoo artists and body piercers ask for identification and will not work on someone underage. "We card everybody that comes in and photocopy the IDs," says tattoo artist Matt Bennett. "If an 18-year-old girl walks in and wants a tattoo on her hand, I won't personally do it; I'll try to talk her out of it because it's something that lasts forever. If someone comes in drunk, I definitely won't serve them."[18]

Does getting a tattoo or body piercing sound interesting? People who are thinking about it need to know some important things before making the decision.

4

Warning! Body Art Danger Ahead!

"Come on in here; let me take a look at that."

Gina was passing a tattoo studio on a street in Mexico, where she was on vacation, when the tattoo artist called to her. He saw an old tattoo of a cross and rose, done by a boyfriend when she was only sixteen, peeking out from under her halter top. "He asked who on earth did that terrible tattoo and offered to redo it for $50," Gina, now age twenty-five, says. "I knew it was Mexico, but he had a license and everything looked pretty sterile."[1]

Gina let him redo the tattoo, coloring it and adding thorns to the rose stem. The next day her skin was swollen, red, and scabby; it hurt so much she could not sleep that night. But then it started to heal and Gina thought the problem was over. A few days later she became very sick, with nausea, hot sweats, and chills. After coming home she went to a doctor who ran some tests. Gina was told she had hepatitis B, which

can be transmitted by unsterile needles and contaminated water.[2] After treatment, she recovered, but it was not pleasant. "It was just the worst feeling, I can't describe how bad it was," she says.[3]

There is no way to know if Gina got hepatitis from the tattoo procedure or from something else, or if she got it in Mexico or in the United States. While no one can say her tattoo caused her to get sick, there is no doubt that it put her at risk.

Most tattoos and body piercings done by professionals heal easily. Yet, people considering getting either need to know the risks before making a decision.

Risks in Getting a Tattoo

I would tell kids not to do it before they can legally. If you have a friend do it in the basement, something is probably going to go wrong, and it's not worth a really big skin infection. Then it gets ruined anyway by the infection, and it's never going to look right.

Dave, age twenty-five[4]

"Any time a needle is used to prick the skin on one human being and then another, there is the risk of passing germs carried in the blood," says Dr. Brian Buggy, a professor of medicine at the Medical College of Wisconsin. "Those include hepatitis B, hepatitis C, and HIV. They are the big three, and most people wouldn't want to have them."[5]

About 1.25 million Americans have hepatitis B and 3.9 million have hepatitis C.[6] Both types can cause liver problems including scarring, failure, and death. Most people who get hepatitis B will recover with no permanent damage, says Dr. Buggy. But hepatitis C can become chronic, which means it hangs on for years, slowly damaging the liver.[7] A scientific study in 2000 found that tattoos are now the leading cause of hepatitis C. The study found that tattoos from commercial

parlors caused about 40 percent of the cases of the potentially fatal virus, which affects 2 percent of the U.S. population.[8] Both diseases are spread person-to-person through infected blood and sexual contact; in rare cases they have been spread through food or water.[9]

Other studies that looked at the risks of disease from tattooing have given different results. One, reported at an American Association for the Study of Liver Disease conference, found that tattoos were not a risk. But another study at the same conference showed a small but real risk.[10] While in theory it is possible to get HIV from a tattoo needle, there is no evidence that it has ever happened.[11]

"There are good tattoo places that use sterilized equipment and disposable needles. OK. But there are also places that don't," says Dr. Buggy. "You pay your money and take your chance."[12] The risk, no matter how small, means it is very important to choose your tattoo studio carefully, making sure they use disposable needles and a sterilizing unit called an autoclave.

Hepatitis and HIV are not the only risk; there are some others. Some people are allergic to ink (especially red) and can develop swelling or itching; being in the sun can make it worse.[13] Some people develop thick scars at the tattoo site. Iron oxide used in some inks can injure tissue during a magnetic resonance imaging (MRI) test.[14]

Risks in Body Piercing

I have two younger sisters who look up to me. They want to have their tongues and nipples pierced, but I told them to wait until they are 18. Then they wanted to do it themselves but I told them they could hit something or mess something up on your body that could mess you up long term.

Colleen, age eighteen[15]

Because body piercing uses a needle to make a hole, the risks of getting hepatitis and HIV from a piercing are the same as from a tattoo. But body piercing carries some of its own risks.

"A new hole in the body, until it becomes a sealed tract, and sometimes even after, causes a risk of bacterial infection," says Dr. Buggy, "from staph and strep germs, ordinary things in the environment around us."[16]

He points out that the risk in piercing earlobes is small, and infections are easily treated. There is more risk in piercing other parts of the ear and parts of the nose, such as the septum (the divider between the nostrils). Those areas are

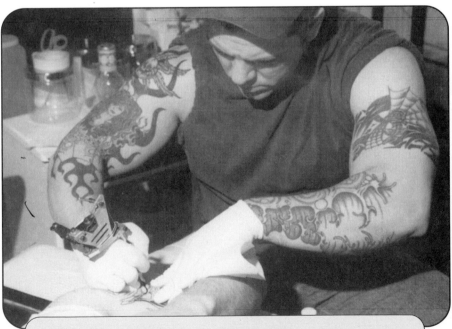

It is important to choose a tattoo parlor that uses sterile equipment and disposable needles. This man is wearing gloves as an added safety measure.

made of cartilage, a tough, rubbery tissue, rather than the soft, fatty tissue of the earlobe or outer nostril. "When cartilage gets infected it's bad news," Dr. Buggy says. "It's harder to clear up, and many times it just doesn't. It's risky to pierce cartilage."[17]

Other areas of the face such as lips, eyebrows, and cheeks are soft tissue, so there is less risk. However, Dr. Buggy says, an infection in any piercing can leave a visible scar.

There are some other risks to think about:

- Mouth and tongue piercing—Bacteria live in the mouth, so a piercing can infect easily. The American Dental Association says mouth piercing of any kind is dangerous. Jewelry can chip teeth or injure gums. It can cause loss of taste from scars or slurred speech.[18] Lip piercing can injure saliva glands and cause drooling.[19]

- Nipple piercing—Scar tissue could cause problems later in life when a woman wants to breast-feed a baby.[20]

- Navel piercing—Done through the little flap of skin above the opening, it works best on people whose navels poke in ("innies") rather than flare out ("outies"). If the piercing is not deep enough, the body can push the ring out and leave a scar, more likely to happen to "outies." Because clothes rub against the piercing, it can be irritated and infect easily.[21] Some piercing studios offer special bandages just for navel piercings.

There are a couple of other things that can affect body piercings:

- In people with certain kinds of heart disease, getting a body piercing could lead to an

infection of the heart valves.[22] People with a bleeding disease called hemophilia should never be pierced, because they may bleed too much at the site.[23]

- Jewelry that contains brass or nickel can cause an allergic reaction with crusting and itching. Body jewelry should always be made from surgical grade stainless steel, 14-karat gold, or titanium.[24]

- Home piercings can hit a facial nerve causing paralysis. Using sewing needles or pins can cause infection and blood poisoning.

Body piercing carries some of the same risks as tattooing as well as a few of its own. Before deciding on a place to get the piercing done, ask how they keep the place sanitary. Find out what precautions they take to prevent the spread of disease or other complications.

- Some people, especially African Americans, form thick scars which may have to be surgically removed. Jewelry can catch, rip loose and cause a scar to form.[25]

- Jewelry can move around, ending up in a different spot from where it was placed. Sometimes the body rejects it and pushes it out. If the jewelry is too thick for the tissue, the risk is higher.[26]

- Barbells in the upper ear can leave grooves in the outer ridge from the pressure of sleeping with it pressed to a pillow.

- Jewelry can interfere with X rays, CAT scans, or metal detectors.[27] Taking jewelry out quickly, especially in an emergency situation, can lead to damage.

Laws About Tattooing and Body Piercing

Laws vary from state to state, and some state laws are being changed as this is written. Some states make tattoo and body piercing studios get a license and be inspected regularly; some also make the artists get a license. Others do not.

As we have mentioned, some states ban tattooing altogether. Banning raises issues of free speech. The American Civil Liberties Union (ACLU) has led several lawsuits to overturn bans. Public health officials say it is not about free speech, but about public health. As the debate continues, laws may change again.[28]

5

Getting a Safe Tattoo or Body Piercing

I had no complications at all. As long as you go to a good shop where they use all new equipment, they sterilize everything, they are real careful about everything, you aren't going to have any complications.

Dave, age twenty-five[1]

The number one factor in getting a safe tattoo or body piercing is to choose a professional artist or piercer to do it.

Debbie, age thirty-three, is an example of how to get a safe piercing. When she decided to get a navel piercing, she wanted it done by a professional. She checked out a studio down the street from the factory where she works and found it was owned by a trained professional piercer.

"At first I wanted to do it just to irritate my husband!" she laughs. "But now he's decided he likes them, so I really don't have a reason. I just figure it's easier than a tattoo."[2] Debbie unzips her jeans so her navel shows. The body piercer, his own face glinting with ear and lip jewelry and wearing sterile

gloves, cleans the area with disinfectant. He uses a marking pen to make a dot at the exact spot where the ring will go. He changes gloves while Debbie lies down on the piercing table. Explaining each step, he uses a clamp to pinch together the circle of flesh at the top of Debbie's navel. Then he takes a sharp needle with a ring attached and quickly pokes the needle through the flesh, pulling the ring through. Debbie tenses, she opens her mouth and winces in pain. But it lasts just a second. Debbie stands up and looks down at the tiny gold ring lying snugly inside her navel.

The tattoo artist sits in a chair on wheels. Next to him a rolling table holds tubes, bottles, jars, spray bottles, and paper towels. Wearing latex gloves, he grips the handle of the electric tattoo machine, about the size of a power drill. His foot rests on the foot pedal. A young man sits in a specially designed chair, his arm resting on a wide armrest. He is reading a book while the artist works on a heavy, black design in the tribal style on his forearm. The tattoo machine buzzes like a dentist's drill, but quieter. Every few minutes the artist stops, sprays the arm with green soap and wipes it with a fresh paper towel. The towels go into the trash immediately. Every five minutes or so, the young man begins to fan himself with his book, indicating that the pain is becoming too much. The tattoo artist stops, sprays the area, and waits a bit before beginning again. This

The person performing a piercing should clean the area to be pierced and explain each step before proceeding.

design, because it is so dark and heavy, will need about four or five hours to finish.

Making a Good Decision

The reason I got my tattoos where I did is so I could cover them up if I need to. I do know they are not extremely professional, but I also think it's more common today to have them. People shouldn't think anything bad of you if you have one, but the stereotype is that they do think bad things.

Heather, age twenty-two[3]

I think piercing is way better than a tattoo. If you don't like it you can always take it out, and the hole will close.

Kim, age eighteen[4]

People who think they want a tattoo or body piercing need to be over age eighteen, understand the danger of infection (and be willing to do what has to be done to prevent it), and have thought through the fact that a tattoo is forever and cannot be removed easily or cheaply. In addition, they have to think about the effect the tattoo or piercing will have on others when they interview for a job or college admission or want to start a new romantic relationship. They need to realize that the decision to get a tattoo or body piercing is not the same as the decision to buy a pair of shoes or even a car—it is much more serious and long-lasting. The person who knows and understands all that may think the research is over. But it really has just begun.

It is not enough to look at statistics about general risk. People have to look at their individual risk carefully and decide if this would be a good thing for them.

The person needs to ask if there is anything in his or her medical history that would make tattooing or piercing dangerous, such as diabetes, blood-clotting problems, heart

Before getting a tattoo or piercing, consider the effect it may have when interviewing for a job or for college.

problems, or a history of forming large scars.

He or she needs to know that in most states people cannot give blood for a year after getting a tattoo or piercing.[5]

If none of those things is a problem, the person needs to think about pain. Is he or she sensitive to pain? Some people say that tattoos and piercings do not hurt very much. Others say the pain is intense. Tattoo artists and body piercers generally do not use anesthetics. Jamie Mills, a body piercer, says he once had a football player faint after a piercing. "He stood up. I was going over the aftercare with him and he started passing out," he remembers. "I tried to grab him but I couldn't. He fell back onto a wooden chair and cracked it!"[6]

Choosing a Tattooist or Body Piercer

I think high school kids that are looking at getting a tattoo really need to think about what they want to get because this is long term. If you are going to get a tattoo, wait and get one that's professional, that's done in a clean place where they autoclave and sterilize, and where someone is talented enough to give you a good tattoo.

Marsha, age thirty-two[7]

If all these things are a go, the last step is to decide where to have it done. People should never try to do a tattoo or body

Kim's Story

Kim, age eighteen, got her tongue pierced because all her friends were doing it. "It just seemed interesting at the time," she says. "I thought 'That looks pretty cool.' I asked if it hurt and my friend said no, so I thought it would be interesting. It's not like doing drugs or anything; if you don't like it, you can just take it out."

So she went with her friends and had it done. She did not find it very painful, but says the worst thing about it was having to gargle with mouthwash to keep it clean. "That was so nasty," she says. "I hate peppermint, it was gross. In about five seconds my eyes were tearing."

Then she got a new job and her employer would not allow a tongue piercing. So she came back to the studio to buy a tongue spacer. "It's a clear piece that goes in the middle of your tongue," she says. "You can't see it at all. It basically looks like you have a hole in your tongue."

Kim now takes the tongue jewelry out and puts in the clear stud every day before she goes to work. She puts the tongue jewelry back in at the end of the work day.

Even with the extra work, she is not sorry she got the piercing. "It's fun," she says. "It's something to play with, it helps you not bite your nails!"[8]

piercing themselves. Home-done tattoos are usually scratched into the skin with tools that are not sterile and use ink not made for tattoos. They almost always look ugly and can infect easily.

Home piercing is very dangerous. Even if the needle is sterilized with alcohol or a flame, there is still a high risk of getting bacteria in the hole. Using nonprofessional jewelry is also asking for trouble. "There is no way that a teenager

piercing friends is going to be as good as somebody who makes a living doing it," says Dr. Buggy. "They just won't have the technical skills."[9]

People getting a tattoo or body piercing should find a well-trained person working in a clean tattoo or body piercing studio that is inspected regularly.

"You can usually tell a lot just by walking in a studio and looking around," says Matt Bennett, a professional tattoo artist. "If everything looks clean, that's a good sign."[10] But it is just a first sign; you cannot judge only on the basis of looking good.

"You want to have a checklist of questions to ask the person," adds Mills. He suggests people ask:

1. How they sterilize their instruments.
2. If they reuse needles.
3. What kind of jewelry they use for piercing.
4. Their experience—more is better.
5. If they use piercing guns. Piercing guns should never be used, he says, because they cannot really be sterilized between uses.
6. Their references. "There are a lot of people out there that don't know what they are doing and are just in it for the quick dollar," he says. "They're basically hackers and they can do a lot of damage."[11]
7. Their training. Mills points out that he has done an apprenticeship in a piercing studio as well as taken classes in sterilization, blood-borne bacteria, first aid, and CPR. Look for a tattoo artist or piercer with the same kind of training.[12]

A few other tips:

⬭ Be completely comfortable with the tattoo artist or body piercer; do not be bullied into making a decision.

- Ask to see the autoclave (the toaster-oven-sized sterilization unit) and the certificate that says it works. Ask if it has been tested recently and what the results were.

- Look at the wall to see if there are diplomas for classes or membership in professional tattooing and piercing organizations.

- Ask if the tattoo artist or piercer wears latex gloves and how often they are changed. If you see the artist or piercer pick up the phone or do paperwork with gloves on and not change them, leave.

- Ask if the tattoo artist uses individual pots of ink and throws out whatever is left. Leftover ink should never be put back into a larger jar.

- Watch the artist or piercer take the equipment out of the autoclave, or take sterile needles from the package. If he or she does not do that, leave.[13]

In the case of tattooing, there is one other thing to think about: the artist's style. "Different artists do different styles of tattoo art," says Bennett. "Each artist has his own style and that's what makes it special. It's not like getting a haircut. Haircuts grow back, tattoos don't. Ask to see a portfolio of the artist's work. You'll be able to tell if someone can do what you are looking for."[14]

Taking Care of a Tattoo or Body Piercing

Before—Get a good night's sleep. Eat a regular meal; an empty stomach is not good. Do not drink alcohol or use drugs. Especially important, do not make the decision to get a tattoo or piercing while under the influence of alcohol or

A Piercee's Bill of Rights[15]

1. To be pierced in a scrupulously hygienic, open environment, by a clean, conscientious piercer wearing a fresh pair of disposable latex gloves.

2. To have a sober, friendly, calm, and knowledgeable piercer who will guide him or her through the piercing experience with confidence and assurance.

3. To have the peace of mind that comes from knowing that the piercer knows and practices the very highest standards of sterilization and hygiene.

4. To be pierced with a brand new, completely sterilized needle, which is immediately disposed of in a medical sharps container after use on the piercee alone.

5. To be touched only with freshly sterilized, appropriate implements, properly used and disposed of or resterilized in an autoclave prior to use on anyone else.

6. To know that piercing guns are never appropriate, and are often dangerous, when used on anything including earlobes.

7. To be fitted only with jewelry that is appropriately sized, safe in material, design, and construction, and which best promotes healing. Gold-plated, gold-filled, and sterling silver jewelry are never appropriate for any new or unhealed piercing.

8. To be fully informed about proper aftercare, and to have continuing access to the piercer for consultation and assistance with all his or her questions related to piercing.

drugs. A good tattooist or piercer will not work on a person who is drunk or high.

During—Have a bottle of water handy. Do not be afraid to ask the tattoo artist or body piercer to stop if the pain is too much. Dizziness may be a warning of fainting; ask the artist or piercer to stop and put your head between your knees. Consider whether or not to continue.

After—A tattoo or body piercing needs to be taken care of while it is healing to prevent infection and scars.

To care for a tattoo:

- Keep it bandaged for the first twelve hours.
- Once the bandage is off, wash it gently with soap and water and rinse carefully. Do not put another bandage on it.
- With freshly washed hands, put on a thin film of antibacterial ointment. Do this three times a day for a week. Do not let the tattoo dry out; use a sensitive-skin hand lotion. Do not use a petroleum jelly such as Vaseline, and do not put alcohol on it.
- A layer of flaky skin will develop; let it fall off naturally. Do not rub it or pick at it.
- Stay out of the sun for at least two weeks.
- Do not swim, go in a hot tub or sauna, or even soak in a bathtub for a week.[16]

Care of piercings depends on the place that is pierced.

- In general, clean the area with antibacterial soap twice a day. Wash the area, removing all the crusts and dried blood. Be sure to rinse off all the soap.
- Soak the part in warm salt water to loosen crusts. Do not use alcohol or peroxide; they are too drying.

- Wash hands before touching a pierced part; do not let anyone else touch it while it is healing.
- Sweat can make a piercing sting; rinse off after exercising.
- Only clean clothes should touch the piercing, change bed sheets every week while it is healing.
- Do not go swimming or in a hot tub, especially a public one, while the piercing is healing.[17]

Here are some tips for caring for particular piercing sites.

- Tongue—The tongue normally swells for a few days after piercing; try sucking on ice chips. Sleeping with the head propped up the first few nights can help. Usually a tongue piercing will be done with a piece of jewelry that has a longer post to make room for the swelling; it will need to be replaced with a shorter one when the swelling is gone. Rinse the mouth several times a day with an antibacterial mouthwash that does not contain alcohol, or with warm salt water. Get a new toothbrush. Brush the jewelry gently with a soft toothbrush to get rid of crusts or dried blood. The balls at the end of the post must be checked every few days to make sure they do not come loose. Be careful eating until the jewelry feels natural. Take small bites and chew carefully. The first few days most people want to eat only soup or other soft foods. Do not chew gum or objects like pencils, play with the jewelry, or irritate it by sticking out the tongue to show it to friends. Do not share cups or forks and spoons; smoking may irritate the piercing.[18]
- Ear cartilage—Keep makeup and hair spray away from the piercing. Change pillow cases

often. Disinfect the telephone and do not use public phones for a few days.[19]

- Nipple—Sleep in a cotton top. Be careful about pets being in bed. Change the sheets often. For women, a soft sports bra may be most comfortable for a few days.[20]

If all that sounds like a lot of work and risk, there are alternatives. Temporary tattoos can look very real and last from a few days to a few weeks. Several types of magnetic jewelry look like real body piercings but without the permanent hole.

Healing Time for Body Piercings[21]

- Earlobe. 6—8 weeks
- Ear cartilage. 4—12 months
- Eyebrow. 6—8 weeks
- Nostril . 2—4 months
- Nasal septum 6—8 months
- Nasal bridge. 8—10 weeks
- Tongue . 4 weeks
- Lip . 2—3 months
- Nipple. 3—6 months
- Navel . 4—12 months
- Female genitals 4—10 weeks
- Male genitals 1—6 months

Alternatives to Tattoos and Body Piercing

Temporary tattoos can be bought at some tattoo studios, boutiques, or over the Internet. Printed on paper, they are wet, stuck on, and the paper peeled off leaving a design. If protected, they can last a week.

One type of temporary tattoo can last for several weeks. Called Mehndi, it uses an orange-brown dye called henna. Mehndi is a five-thousand-year-old tradition from India where it is often used to decorate a bride's hands and feet for her wedding day. Many of the patterns are very old, handed down from mother to daughter. Sometimes the groom's name is hidden in the twists and curls of the pattern.

Henna comes from a shrub; leaves and twigs are ground up to make a powder that is mixed with hot water to make the dye. True Mehndi designs take a lot of practice to do well.

There are also alternatives to body piercing. Several manufacturers make magnetic jewelry; strong magnets hold it in place. Magnetic jewelry can be used on ears, noses, and lips. One maker of magnetic jewelry says they have saved people from getting more than a million new holes.[22]

People who have made a good decision and taken care of their tattoo or body piercing carefully will probably be happy with it. However, some people are not. The next chapter shows what happens when things do not go well.

6

When Things Do Not Go Well

I have three children. I hope they won't want tattoos. They know that I'm sorry I did it. My daughter was with me when I got one of them. She says that she won't do that to her body.

Lisa, age thirty-three[1]

It was my sixteenth birthday. I went to a friend's house. I was kind of drinking, and this guy said, "It's your birthday so I'll give you a tattoo for free." He did it, and it hurt pretty bad. At first it looked nice, but I was scared to show my parents. They didn't see until I was eighteen. It started to fade and I was very unhappy with it.

Gina, age twenty-five[2]

Caitlin, age eighteen, got her tattoo—a small twist of green leaves and red roses at the bottom of her spine—just because she liked it. "I'm an art student and I like art in all forms," she says. "I saw this cute little tattoo and I got it."[3] She did not tell her parents. Then one day she bent over, her shirt hiked up, and her father saw it. He was not pleased.

"He told me that he wouldn't pay for me to go out of state to college unless I got the tattoo removed," Caitlin says. "I don't want to live at home and go to the local college. It's costing about $2,000 to have it removed—I'm thinking that's my contribution to going to college!"[4] Many people would not agree with Caitlin's parents, but that is another issue.

Kristy, age nineteen, hid her tattoo on her arm from her mother for a couple of months. When she showed it to her, her mother was not happy either. She pointed out that when Kristy got married, the tattoo, not her bridal gown, would be what people noticed first. In addition, her boyfriend hated it, and her employer told her they did not allow visible tattoos because it looked unprofessional.[5]

Sometimes people who have tattoos or body piercings change their minds and wish they had not done them. Their reasons vary. The university professor who studied tattooing asked people several years later what they thought about their tattoos. Sixty-four percent of the people he talked to had no regrets. Twenty-one percent thought the quality of their tattoo was not as good as they would have liked, and 8-1/2 percent no longer liked the design. Three-and-a-half percent no longer liked the effect of the tattoo, and 0.1 percent did not like the location.[6]

Another survey of 105 men and women having laser treatments to remove a tattoo showed that most of them were doing it for themselves rather than to please employers or others. Eighty-five percent said they wanted to remove it to "help me feel better about myself." Sixty-one percent thought that removal would help people judge them for who they are rather than for the tattoo.[7]

Removing a Tattoo

Many methods have been tried to get rid of tattoos; they all left scars:

Lisa, Who Wishes She Had Not

Lisa, age thirty-three, got her first tattoos at eighteen because "everybody was doing it." Her boyfriend, who had training in tattooing, did the first ones: a rose on her shoulder and a spiderweb on her buttocks. Later she added a butterfly on her hand and a flower on her leg.

Now, fifteen years later, she wishes she had never gotten them. "I am sorry I had them done," she says. "They don't look nice. They are too big. I'm a small person and something that big doesn't look good on me. My hands don't look right. My girlfriend was with me, she kept asking if I was sure. I thought they were cool but they aren't cool."

Lisa would like to have them removed but it is too expensive for her. "I don't have the money," she says. "I'm afraid I would have scars, I'd rather have something there than scars.

"I think kids should think about it, not rush into it because everyone has one," she continues. "You will have them for the rest of your life."[8]

- Cutting the tattoo out and stitching the skin together. Sometimes the skin is stretched first, in other cases cutting the tattoo out has to be done in stages.
- "Sanding off" the tattoo. Called dermabrasion, this method uses an instrument to sand the skin to remove the top layers. Salabrasion is a very old method that uses salt.[9]

The newest and best method of tattoo removal uses a laser. "About eight years ago a new type of laser called a cutaneous laser, which means a skin laser, was developed," says Cindy Graf, laser coordinator at the Laser Centers of Wisconsin.

"These new lasers are attracted to certain colors such as tattoo ink in the skin. Only the colored ink absorbs the laser beam; it breaks up into tiny pieces so the body can carry it out in the urine."[10]

She explains that different laser wavelengths are attracted to different colors so black, red, and several other ink colors can be broken up. A few colors such as purple, yellow, green, and bright blue are harder to remove. The key, she says, is having many treatments six weeks apart to allow time for the body to remove the ink. The process is safe if a trained person is doing it; treatments are done by doctors or laser technicians.[11]

After the treatment, the area seems mildly burned and may develop an itchy crust. It is kept bandaged for three days to a week. The brighter the color, the more dramatic the results, Graf says, so the first two treatments will show the most improvement.[12]

People thinking about tattoo removal should be aware that the result is not guaranteed. There can be some scarring and the skin texture may look different where the tattoo was removed.

Caitlin stretches out on the table, lying on her stomach. Beside her the laser technician, wearing safety goggles, holds a long tube with an opening the size of a test tube attached to the laser machine. She puts

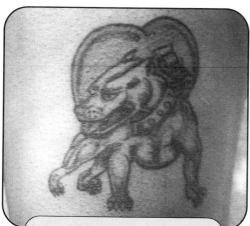

Some people with body piercings or tattoos change their mind and no longer want them. Getting a tattoo removed is a very costly and time-consuming process. It may also be very painful, and may leave scarring.

the open end of the tube on a few leaves or flowers from Caitlin's tattoo. She turns on the laser; it sounds like little pops as the light beam hits Caitlin's skin. The skin immediately bubbles up into little white blisters. The technician asks Caitlin if she is OK. Caitlin responds that she is fine. "Just get it over with," she says.[13]

For many people, the removal process hurts about as much as having the tattoo done in the first place, Graf says. For others, it is much more painful. They do use a cream that numbs the area before beginning the treatment.[14]

A big problem with tattoo removal for most people is the cost. Removing a large tattoo can cost thousands of dollars—much more than the cost of getting it. Health insurance does not cover tattoo removal because it is not done for health reasons.

Removing a Piercing

For her twenty-first birthday, Jenny visited her sister in San Francisco. Her sister offered to pay for a nose piercing as a birthday present. Nose piercings were all the rage in California at that time, but quite rare in the rest of the country.

"The piercer disinfected the area and put the needle through the side of my nostril," she remembers. "I started to bleed. I could feel the blood running while the piercer was putting pressure on my nose trying to get it to stop. I was getting faint and thinking I was going to pass out."[15]

Finally the piercer got the bleeding stopped and put in the stud. When she returned to her small Midwestern town, her parents and her boyfriend were shocked. She went back to her job working with emotionally disturbed kids and realized how easily the stud could be ripped from her nose while trying to hold an upset child. Then allergy season started. "My nose was always running," she says. "It got really messy trying to blow my nose all the time with that stud in it. Finally, I just got disgusted with the whole thing and took it out. It

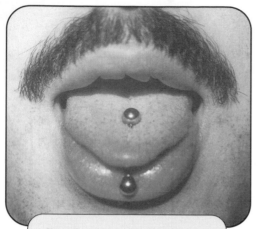

Jewelry for a piercing is easy enough to remove or have removed. However, the hole may or may not close, and it may also become infected.

healed OK and didn't leave a scar. I don't miss it all!"[16]

It is a lot easier to get rid of a body piercing than a tattoo. Most of the holes heal quickly. But if the piercing has been infected, it can leave a scar. Some people, says Dr. Buggy, the infectious disease doctor, have had a hard time clearing up an infection, especially in cartilage. "People can wind up losing pieces of ear or nose, getting the infection cut out," he says.[17]

To avoid problems in the first place, think carefully about the decision. Some questions to consider include:

- How will other people—parents, friends, employers, or romantic partners—react to the tattoo or piercing?
- What effect will it have in the future—in the event of weight gain or loss, or pregnancy? Piercing also may affect breastfeeding.
- Will there be a danger of jewelry being caught and ripping out? If it leaves a scar, will it be noticeable?

The decision to get a tattoo or body piercing should never be made lightly or on impulse. The best way to avoid having to have one removed is to be absolutely sure it is wanted for a lifetime before getting it.

7

Extreme Body Modification

There are some people who want to take decorating their bodies a little further. Some want to shock people or to express themselves in an unusual way. So they pick unusual areas to tattoo or pierce, or use methods such as implants or branding—all called "body modification."

Extreme Tattooing

Some people cover big sections of their bodies with tattoos; artists call full-arm tattoos "sleeves," full chests and backs "vests," and whole body "body suits." One full-body tattooed man says, "It's the only thing I'm going to take with me when I'm dead."[1]

The host of a television investigation show on tattoos may have summed it up best when he said, "Like all art, tattoos cause an emotional response. You either love them, hate them, or just don't get them!"[2]

The Dark Side of Tattooing

Tattoos sometimes identify members of criminal gangs, occult cults, or violent groups such as skinheads through gang signs, occult symbols, or Nazi symbols. Sometimes they are in hidden areas, but often they are on hands or wrists as a sign of loyalty.[3]

Gang tattoos make it hard for people to leave the gang life. Having a gang tattoo, especially on the hands, can mark them as criminals, making it hard to get a job; rival gang members can continue to harass them. Because many former gang members do not have the money to have the tattoos removed, some cities have tattoo removal programs so former gang members can have their tattoos taken off in return for community service.

One example is the "Lose the Tattoos" program in Milwaukee, Wisconsin. It was started in 1999 by Dr. Roger Mixter, a plastic surgeon, working with the Wisconsin Laser Center. The Center raised money from people and companies to pay for four tattoo removal clinics a month at different Boys and Girls Clubs. Former gang members must do forty to eighty hours of volunteer work such as working with younger kids or cleaning up graffiti.[4]

"Every time I shake hands with someone all they see is my gang tattoo. I haven't been in a gang since I was 15. This is not my image anymore. I am back in school and have a family," says Dawn, a nineteen-year-old who had her tattoo removed through the program.[5]

Extreme Body Piercing

One apprentice at a body piercing studio has a line of ten tiny silver rings following the arch of her eyebrow. A man in a television program on body piercing has his entire face covered with rows and rows of hundreds of silver rings that jingle when he moves.[6]

A twenty-year-old pierced the flap of skin that hangs down at the back of the throat, called the uvula. The hoop came open and he swallowed it. No harm was done, but he could have breathed it into his lungs and done a lot of damage.[7]

Some people, both males and females, have their sexual organs pierced. There are many risks with genital piercing. Even though urine is sterile, the colon contains many bacteria that can cause infections. Because the piercing hole is a direct opening into the bloodstream, bacteria and viruses that cause sexually transmitted diseases can easily get into the body. Teens thinking about genital piercing should consider how future sexual partners will feel about it and how they might feel in locker-room situations. After a genital piercing, people should wait until it is healed (three to six months) before having sex. Because condoms can break, they should use two or three for all sexual activity.[8]

Body Implants

A new form of body modification involves putting something under the skin to form a raised design. In one type, called a "Madison," a barbell (two balls connected by a post) is put between the points of the collarbone. One ball stays on top of the skin, the other under it. Another method is to put tiny metal balls or pieces of Teflon foam under a tattoo to make it look three-dimensional. Some people have implants under the skin of their skulls to make it look like they have horns. Implants that are put in place by a body piercer are very dangerous. The piercer, who is not a doctor, is cutting through the skin in a mini-operation. The risk of infection is high.[9]

Branding, Cutting, and Scarring

"Scarification" is the process of cutting or burning the skin to create a pattern of raised scars. Sometimes it is called "keloiding" because keloid is a medical term for a thick,

heavy scar. It is popular with African-American fraternities; black skin tends to scar more easily than lighter skin, making a pattern that may show up better than a tattoo. The Reverend Jesse Jackson and football star Emmitt Smith are two famous African Americans who have brands.

Scars can be made by cutting the skin with a thin blade, or by holding a piece of hot metal against the skin, called a "strike." Every person's body makes scars differently, so the person doing scarification does not really know what the design will look like when it is healed.

People branding or cutting themselves are taking a big risk. First of all, the pain can be intense and healing can take a long time. Infection is always possible if the tools are not sterile or if ink is rubbed in to make a colored scar. Sometimes paper clips or soldering irons are used; they do not give a clean line. Branding or cutting should only be done by trained professionals.[11]

Tattooing and body piercing have certainly become popular in today's teen culture. No one can say that they are right or wrong, but teens need to think very carefully about the decision to have one. They need to consider many factors:

- Their own maturity and ability to make a decision about something that will be with them for the rest of their life.

- The risks of infection, disease, or scarring.

- The reaction of others—friends, romantic partners, parents, future college interviewers, or employers. Having a visible tattoo or body piercing can cause people to assume things about someone that may not be true.

- The work involved in preventing infection.

- The difficulty and cost of removal, especially for tattoos.

Before getting a tattoo a person should consider many factors, such as which part of the body to get done. Something to keep in mind while deciding is whether or not it can be covered for a job if necessary.

- Their own motivation—Getting a tattoo or body piercing no longer makes a person look different.
- The skill and cleanliness of the artist or piercer they are considering.
- Alternatives such as temporary tattoos or magnetic jewelry.

After careful consideration of all these factors, then—and only then—is a teenager ready to make this important decision. That is only if a teen is eighteen or older for a tattoo. Tattoos are against the law for people under eighteen.

For More Information

Tattoo Museums
Tattoo Archive
2804 San Pablo Avenue
Berkeley, CA 94702
(510) 548-5895

National Tattoo Museum
3216 Kensington Avenue
Philadelphia, PA 19134
(215) 426-9977

Internet Addresses

Association of Professional Piercers
<www.safepiercing.org>

Information on body piercing
<http://www.safepiercing.org/guides/body.html>

Information on temporary tattoos
<http://www.temptu.com>
<http://www.hennamehndi.com>

Chapter Notes

Chapter 1. What are Tattoos and Body Piercings?

1. Telephone interview with Marsha, July 16, 2000.
2. Ibid.
3. Ibid.
4. Ibid.
5. Personal interview with Lisa, July 10, 2000.
6. Personal interview with William, July 26, 2000.
7. Personal interview with Vicki, July 26, 2000.
8. Telephone interview with Beth, July 31, 2000.
9. Clinton R. Sanders, *Customizing the Body: The Art and Culture of Tattooing* (Philadelphia: Temple University Press, 1989), p. 136.
10. Personal interview and observation with Matt Bennett, professional tattoo artist, July 20, 2000.
11. Anne Lederberg, "Marked for Life," *Science World*, March 9, 1998, vol. 54, issue 11, p. 48.
12. Charles Clayman, M.D., ed., *The American Medical Association Family Medical Guide* (New York: Random House, 1994), p. 267.
13. "Tattoos: Skin Deep," *MSNBC Investigates*, ©MSNBC 2000, broadcast October 11, 2000, and personal interview and observation with Matt Bennett, professional tattoo artist, July 20, 2000.
14. Personal interview and observation with Jamie Mills, professional body piercer, September 8, 2000.

Chapter 2. Body Decoration in History

1. Clinton R. Sanders, *Customizing the Body: The Art and Culture of Tattooing* (Philadelphia: Temple University Press, 1989), p. 9.
2. Ibid., p. 10.
3. Ibid., p. 12.
4. Ibid., p. 16.

5. Ibid.

6. Barbara Freyenberger, *Iowa Health Book: Dermatology*, November 1998, <http://www.vh.org/Patients/IHB/Derm/Tattoo/ #1> (June 6, 2000).

7. Ibid.

8. Henry Ferguson, "Body Piercing," *The British Medical Journal*, December 18, 1999, issue 7225, p. 1627.

Chapter 3. Who Is Doing This and Why?

1. Personal interview with Kim, September 8, 2000.

2. Telephone interview with Heather, July 8, 2000.

3. Clinton R. Sanders, *Customizing the Body: The Art and Culture of Tattooing* (Philadelphia: Temple University Press, 1989), p. 32.

4. "Tattoos: Skin Deep," *MSNBC Investigates*, ©MSNBC 2000, broadcast October 11, 2000.

5. Judith Greif and Walter Hewitt, "Tattooing and Body Piercing: Body Art Practices Among College Students," *Clinical Nursing Research*, November 1999, vol. 8, issue 4, p. 368.

6. Amy Krakow, *The Total Tattoo Book* (New York: Warner Books, 1994), p. 9.

7. Mary Lord and Rachel Lehmann-Haupt, "A Hole in the Head? A Parents' Guide to Tattoos, Piercings and Worse," *U.S. News and World Report*, November 3, 1997, vol. 123, issue 17, p. 7.

8. Greif and Hewitt, p. 368.

9. Ibid., p. 370.

10. Personal interview with Laura Lees, Psy.D., March 29, 2001.

11. Greif and Hewitt, p. 368.

12. Ibid.

13. Sanders, pp.42–43.

14. Quoted in Mark Johnson, "Removal Proves Some Mistakes Are Only Skin Deep," *The Milwaukee Journal Sentinel*, February 18, 2001, p. L1.

15. Sanders, p.44–47.

16. Krakow, p.104.

17. "Tattoos: Skin Deep," *MSNBC Investigates*.

18. Personal interview and observation with Matt Bennett, professional tattoo artist, July 20, 2000.

Chapter 4. Warning! Body Art Danger Ahead!

1. Telephone interview with Gina, July 13, 2000.

2. Charles Clayman, M.D., ed., *The American Medical Association Family Medical Guide* (New York: Random House, 1994), p. 523.

3. Telephone interview with Gina.

4. Telephone interview with Dave, July 5, 2000.

5. Telephone interview with Brian Buggy, M.D., August 12, 2000.

6. Centers for Disease Control <http://www.cdc.gov/ncidod/diseases/hepatitis/b/fact.htm> (June 5, 2001); <http://www.cdc.gov/ncidod/diseases/hepatitis/c/fact.htm> (June 5, 2001.)

7. Telephone interview with Brian Buggy.

8. "Tattoos Prime Cause of Hepatitis C, Study Says," *Milwaukee Journal Sentinel*, April 6, 2001.

9. Clayman, M.D., p. 523.

10. Salynn Boyles and Sandra Key, "Studies Differ Regarding Tattoo Risk," *Hepatitis Weekly*, December 8, 1997, p. 6.

11. Kris Sperry, M.D., *The American Journal of Forensic Medicine and Pathology*, January 1992, quoted in Marilynn Larkin, "Health Risks," *FDA Consumer*, October 1993, issue 8, p. 28.

12. Telephone interview with Brian Buggy.

13. Marilynn Larkin, "Health Risks," *FDA Consumer*, October 1993, issue 8, p. 28, and Karmen Butterer, "Tattoos Can Trigger Allergies," *Health*, March 1997, vol. 11, issue 2, p. 240.

14. Barbara Freyenberger, "Tattooing and Body Piercing: Decision Making for Teens," *Iowa Health Book: Dermatology*, November, 1998, <http://wwww.vh.org/Patients/HB/Derm/Tattoo/#1> (June 6, 2000).

15. Telephone interview with Colleen, August 4, 2000.

16. Telephone interview with Brian Buggy.

17. Ibid.

18. Rebecca Voelker, "Quick Uptakes," *Journal of the American Medical Association*, September 24, 1997, vol. 278, no. 12, p. 973 and "News From the World of Medicine," *Reader's Digest*, May 1999, p. 39.

19. Ronna Staley, James Fitzgibbon, and Catherine Anderson, "Auricular Infections Caused by High Ear Piercing in Adolescents," *Pediatrics*, April 1997, vol. 99, issue 4, p. 610.

20. Myrna Armstrong, R.N., "A Clinical Look at Body Piercing," *RN*, September 1998, p. 28.

21. Ibid., p. 29.

22. "Body Piercing Linked with Heart Infection," *Dermatology Times*, July 1999, vol. 20, issue 7, p. 13.

23. "The Hole Story," *Science World (Teacher's Edition)*, February 7, 2000, vol. 56, issue 9, p. 2.

24. Jane Brody, "Looking at the Hole Picture," *The New York Times*, appearing in the *Milwaukee Journal Sentinel*, April 26, 2000, Section H, p. 1.

25. Ibid.

26. Ibid.

27. "Recommended Review: Infections Complicating Body Piercing," *Pediatric Alert*, June 11, 1998, vol. 23, issue 11, p. 66.

28. Kris Axtman, "Tattoo Craze Stirs Concern About Public Health," *Christian Science Monitor*, April 25, 2000, vol. 92, issue 107, p. 2.

Chapter 5. Getting a Safe Tattoo or Body Piercing

1. Telephone interview with Dave, July 5, 2000.

2. Personal interview and observation with Debbie, September 8, 2000.

3. Telephone interview with Heather, July 8, 2000.

4. Personal interview with Kim, September 8, 2000.

5. "Body Piercing: It's More than Skin Deep," *HealthOasis*, the Mayo Clinic, March 24, 1997, p. 2.

6. Personal interview and observation with Jamie Mills, professional body piercer, September 8, 2000.

7. Telephone interview with Marsha, July 16, 2000.

8. Personal interview with Kim.

9. Telephone interview with Brian Buggy, M.D., August 12, 2000.

10. Personal interview and observation with Matt Bennett, professional tattoo artist, July 20, 2000.

11. Personal interview and observation with Jamie Mills.

12. Ibid.

13. "How to Get a Safe Tattoo," n.d. <http:/tattoo.about.com/style/tattoo/library/week1.htm> (May 31, 2000) and Keith Alexander, "Body Piercing: Questions and Answers," n.d. <http://www.modernamerican.com/howcani.html> (May 31, 2000).

14. Personal interview and observation with Matt Bennett, professional tattoo artist, July 20, 2000.

15. American Piercing Association, n.d. <http://www.safepiercing.org/billofrights.html> (June 5, 2000).

16. Amy Krakow, *The Total Tattoo Book* (New York: Warner Books, 1994), p. 79.

17. Barbara Freyenberger, *Iowa Health Book: Dermatology,* November 1998, <http://www.vh.org/Patients/IHB/Derm/Tattoo/#1> (June 2, 2000).

18. "Body Piercing: Aftercare Tips," Association of Professional Piercers Web site, ©2000, <http://www.safepiercing.org/guides/oral.html> (June 5, 2000).

19. "Body Piercing: Aftercare Tips," Association of Professional Piercers Web site, ©2000, n.d. <http://www.safepiercing.org/guides/body.html> (June 5, 2000).

20. Ibid.

21. Barbara Freyenberger, "Tattooing and Body Piercing: Decision Making for Teens," *Iowa Health Book: Dermatology,* <http://www.vh.org/Patients/HB/Derm/Tattoo/#1> (November 1998).

22. Linda Kulman, "How to Save Your Skin," *U.S. News & World Report,* November 3, 1997, vol. 123, issue 17, p. 67.

Chapter 6. When Things Do Not Go Well

1. Personal interview with Lisa, July 10, 2000.

2. Telephone interview with Gina, July 13, 2000.

3. Personal interview and observation with Caitlin, September 9, 2000.

4. Ibid.

5. Quoted in Mark Johnson, "Removal Proves Some Mistakes Are Only Skin Deep," *The Milwaukee Journal Sentinel,* February 18, 2001, p. L1.

6. Clinton R. Sanders, *Customizing the Body: The Art and Culture of Tattooing* (Philadelphia: Temple University Press, 1989), p. 56.

7. Myrna Armstrong, "A Clinical Look at Body Piercing," quoted in Mark Johnson, "Removal Proves Some Mistakes Are Only Skin Deep," *The Milwaukee Journal Sentinel*, February 18, 2001, p. L2.

8. Personal interview with Lisa.

9. Contemporary Health Communications, Earth City, Missouri, ©2000, <http://patient-info.com/tattoo.htm> (June 2, 2000).

10. Personal interview and observation with Cindy Graf, Wisconsin Laser Centers, September 9, 2000.

11. Ibid.

12. Ibid.

13. Personal interview and observation with Caitlin.

14. Personal interview and observation with Cindy Graf.

15. Personal interview with Jenny, November 22, 2000.

16. Ibid.

17. Telephone interview with Brian Buggy, M.D., August 12, 2000.

Chapter 7. Extreme Body Modification

1. "Tattoos: Skin Deep," *MSNBC Investigates*, ©MSNBC 2000, broadcast October 11, 2000.

2. "Tattoos: Skin Deep," *MSNBC Investigates*, ©MSNBC 2000, broadcast October 11, 2000.

3. Mark S. Dunston, *Street Signs: An Identification Guide of Symbols of Crime and Violence* (Powers Lake, Wisc.: Performance Dimensions Publishing, 1992), pp. 48–49 and 91 ff.

4. Personal interview and observation with Cindy Graf, Wisconsin Laser Centers, September 9, 2000.

5. "Lose the Tattoo" brochure, Wisconsin Tattoo Removal Program, Wisconsin Laser Centers, September 9, 2000.

6. "Tattoos: Skin Deep," *MSNBC Investigates.*

7. Christine Gorman, "A Risky Fashion," *Time*, August 31, 1998, p. 77.

8. "Thinking About Getting a Nipple Pierced? Or (Ouch!) Your Genitals?" *Heart & Soul*, April/May 1999, vol. 6, issue 2, p. 18.

9. Tisha Harrell, "Body Modification: There's More Than Just Piercing," "Appearance and Fashion," *The Lycos Network*, September 3, 1999, <studentadvantage.com> (November 21, 2000) and "Tattooing: Skin Deep," *MSNBC Investigates*, October 11, 2000.

10. Ibid., and Shannon Larratt, "BME Branding/Cutting/ Scarring FAQ," February 23, 1996, <http://www.bmefreeq.com/> (November 21, 2000).

Glossary

aftercare—Keeping a tattoo or body piercing clean can help it heal without infection.

autoclave—The sterilization unit used for tattoo and body piercing equipment that uses steam and pressure to kill viruses or bacteria.

blood-borne pathogens—The viruses and bacteria, carried in the blood, that cause diseases such as hepatitis and HIV.

body modification—A term that includes all types of body art including tattoos, piercings, implants, and branding.

branding—Making a pattern of scars by putting a red-hot iron on the skin.

cartilage—The rubbery tissue in the upper ears or the divider in the nose.

cover-up work—A new tattoo that is put on top of an old one to change it, improve it, or brighten the colors.

devotion tattoo—A tattoo with a person's name in it; sometimes also religious tattoos.

fine-line tattooing—A thin outline done with a single needle.

flash—The sheets of pictures of possible tattoos hung on the wall or in books.

gang tattoos—The tattoos gang members use to identify what gang they belong to, often on the hands.

hepatitis—A disease carried in the blood. There are three types: A, B, and C.

implants—Metal balls or pieces of Teflon put under the skin to make raised bumps or a three-dimensional tattoo.

laser—A beam of concentrated light. Different lasers are attracted to different colors and can dissolve tattoo ink.

latex gloves—The thin gloves tattoo artists and body piercers must wear to prevent spreading disease.

needle bar—A narrow bar with many needles attached to it used in tattooing. The bar moves up and down, pricking the ink into the skin.

needles—These are dipped in ink and pricked into the skin to create a tattoo, or used to put through skin to make the hole for body-piercing jewelry. Tattoo artists and body piercers should use disposable needles and throw them away after one use.

pigment—Another name for tattoo ink.

scarification—Making a pattern of scars on the body. It can be done by cutting or with a hot branding iron.

scratcher—A name professional tattoo artists call amateurs who do tattoos at home. Body piercers sometimes called amateurs "hackers."

stencil—A tracing of a tattoo done on the skin before the inking begins.

sterilization—Killing viruses and bacteria that cause disease. It can be done with alcohol, or by heat and steam.

tribal design—A tattoo design that looks like it comes from Native American or Pacific Island sources. Tribal designs are heavy and black.

Further Reading

Glickman, Jane. *The Art of Mehendi: Learn the Ancient Art of Painting Hands, Ankles and More*. Los Angeles: Lowell House Juvenile, 2000.

Graves, Bonnie. *Tattooing and Body Piercing (Perspectives on Physical Health)*. Mankato, Minn.: Capitone Press, Inc., 2000.

Krakow, Amy. *The Total Tattoo Book*. New York: Warner Books, 1994.

Miller, Jean-Chris. *The Body Art Book: A Complete Illustrated Guide to Tattoos, Piercings and Other Body Modifications*. California: Berkeley Publishing Group, 1997.

Reybold, Laura. *Everything You Need to Know About the Dangers of Tattooing and Body Piercing*. New York: Rosen Publishing Group, 1996.

Wilkinson, Beth. *Coping With the Dangers of Tattooing, Body Piercing and Branding*. New York: Rosen Publishing Group, 1998.

Index